Numbers Plus: Scrap Catalytic Converter Guide

Buyers & Sellers Guide Updated

Cameron Rowland

ISBN: 978-3-96098-013-1
Copyright: C.A.G. (Standard Copyright License)
Edition: Final Edition
Publisher: Koenig Books
Published: 2019
Language: English
Pages: 90

Index

Book of Numbers PLUS

Welcome to the fourth edition of Scrap Catalytic Converter Guide, The Book of Numbers PLUS.

Contents in this edition:

Over 350 converters in full color, complete with year, make and model.

Learn the value of each converter under the current market and projected market.

Know the value of scrap catalytic converters by the part numbers engraved on each converter(s):

*All Prices are based on a $1,450 Market. Please increase/decrease prices by $10 per $100.

Chryslers/Dodge numbers:
Round Ribbed
T-backs
10 line
13 line
Round smooth
Flat 6 Ribbed
DPF Systems

GM/Oldsmobile/Pontiac numbers:
Ovals
Roundloaf
Large Breadloaf
X-body
6.0 Pill
Small Flow
Large Flow
Triangles
Small Breadloaf
Turtles/Tahoe
Duramax
Special Square
Cadillac Catera
454

Ford numbers and special grades:
Special High domestic
High Domestic
Regular Domestic
Low Domestic
Special High Pre
CV-Pre
New Pre
Low Pre
Torpedo numbers

Import Numbers and specials:
Toyota Numbers
Forerunner specials
Hyundai Numbers
Kia Numbers
Special Honda's

Buying and selling scrap catalytic converters is a pretty easy process, but what's required the most is, consistency, integrity and knowledge. Let's start first with the selling aspect of it. In order for this process to work fluently, it would be ideal to have a buyer and/or a platform to sell your scrap catalytic converters. Finding local buyers would assure that you have an outlet to quickly sell your converters. Picking a local buyer can be quite exhausting, seeing that you will need to find a buyer that's consistent in pricing, punctual and apt to teach you a little about the buying process and set up to allow you to text photos for quotes. Once you secure a local buyer, it's always a good idea to gather local independent buyers, such as local core buyers and scrappers; this will keep you informed with what's going on in the streets.

Two other outlets that would allow you to gain a lot of knowledge and experience are, eBay and Craigslist. Many people buy and sell converters on these two platforms. Let us focus a little on eBay and what to expect when venturing into this avenue. First off, this is a pretty fierce platform to purchase converters, seeing that there are very knowledgeable and well informed buyers who at time seems that they would do whatever it takes to win an auction, even if it meant walking away with as little as a $2 profit. Buying on eBay would require that you have a very strong buyer, if your buyer is not strong enough to compete with other buyers on eBay, then choosing this platform for buying wouldn't be wise; on the other hand, eBay is an excellent platform to sell catalytic converters. Selling on eBay exposes you to strong and competitive buyers. Selling on this platform would assure you get the most for your material as well as give you an idea on what a converter should be worth, also, it exposes you to other buyers that you can communicate with and gain even more knowledge and prospects. The only downfall with selling on eBay is, waiting to be paid, fees, setting up a Paypal account and shipping your item(s) in a timely manner. Other than that, the financial returns and knowledge acquired are pretty good when using this platform to sell.

 * If you can **afford** taking **risks,** purchase on eBay when the market is down with hopes that the market would jump up prior to you selling. I have personally invested $3,000 in purchasing converters at market value under a low market on eBay and waited for the market to jump before I sold and was able to turn a $500 profit in as little as two weeks.

Buying on Craigslist, is probably one of the most profitable platforms to utilize. Scouring Craigslist on a daily basis would expose you to sellers who are very anxious to sell you their converters fast, for cheap. Most sellers on Craigslist consist of auto dismantlers, those who are parting out vehicles, individuals selling their personal converter(s), etc. Being consistent, determined and available gets you the converters. Staying consistent at posting ads and searching ads is key in make a lot of money from Craigslist.

The downfall of selling on Craigslist is that many thieves have chosen this platform to quickly sell stolen converters and because of this, Law enforcement are running stings all the time, and unfortunately it's often the innocent who get entrapped. Obtaining the proper identification, giving receipts and steering clear from shady looking and sounding deals will help you when using this platform to purchase converters.

Buying outlets: Muffler shops, Exhaust shops, Dealer ships(parts department), Muscle car shops, Performance shops, Wrecking Yards, Scrap yards, eBay, Craigslist, Automotive shops

For you convenience we have included a number that you can text your pictures to for a quote, grade and info on your converters. This number is for text communication only. (214) 299-3252

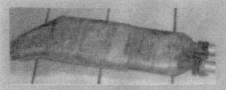

**1986-1991 BMW 325ic, 325is.
1991 BMW 325i**

Price - $200

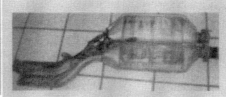

**1989-1993 BMW 535i.
1988-1993 535is.
1987-1993 735il.**

Price - $400

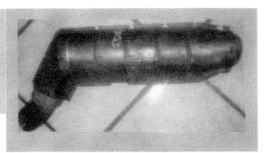

**1998 BMW 323.
1996-1998 325i, is, ic, 328i.
1999 BMW M Roadster.
1997 BMW M5.
1998 BMW M3.
Weight trimmed: 8 Lbs
Price - $12 a Pound**

**2000 BMW 323i.
2000-2001 BMW 325i.
2001 BMW 330i.
1999-2003 BMW 323, 325, 330, 525,
528, 530 I-series & X5.**

Price - $70 ea.

**1997 Mercedes E420.
1998 Mercedes C280, CLK 320.
1998-2003 Mercedes E320.
2002 Mercedes CLK 430.**

Price - $40

**1997 Mercedes E420.
1998 Mercedes C280, CLK 320.
1998-2003 Mercedes E320.
2002 Mercedes CLK 430.**

Price - $150

1992-1995 BMW 325I, ic, is.

Price - $115

1984-1986 Mercedes E190.

Price - $160

**1996 Mercedes C36 AMG, C280.
1994 Mercedes C220.**

Price - $120

**1988-1992 Mercedes SE300.
1990 Mercedes SEL300.**

Price - $300

1997 Mercedes E320.

Price - $260

**1986-1987 Mercedes SL450.
1986-1989 Mercedes SEC560,
SLC380.**

Price - $150

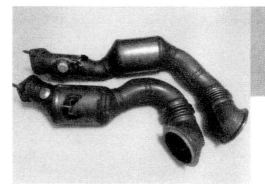

**1983-1984 BMW 533i.
1982-1984 633csi, 733i
1988-1990 635i, CSI.**

Price - $270

**1992 Mercedes E400, SEL500.
1993 Mercedes SEL400.**

Price - $400

**1992-1995 BMW 318i, is.
1996-1998 BMW Z3.**

Price - $240

2001 BMW 740i.

Price - $110

2007 Audi A4.

Price - $85

**2011 BMW 335I.
2008 BMW 135i.**

Price - $45 ea.

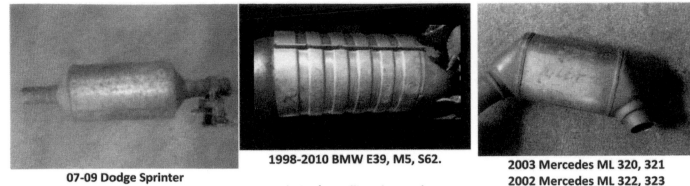

07-09 Dodge Sprinter

Particulate Filter. (3.0L)

Price - $450

1998-2010 BMW E39, M5, S62.

(wire/metallic substrate)

Weight trimmed: 6 Lbs.

Price - $12 a Pound

2003 Mercedes ML 320, 321
2002 Mercedes ML 322, 323
1998-2001 Mercedes Benz Truck ML 320.

Price - $70

2003-2004 BMW M3.

(foil/metallic substrate)

Weight trimmed: 6 Lbs.
Price - $12 a Pound

2002 Audi A8.

Price - $100 ea.

1992 Mercedes Benz CE300, E 280.
1988-1989 Mercedes Benz E 260, E 190
1986 Mercedes Benz SW 300.
1988-1992 Mercedes Benz TE 300.
1988 E 300

Price: $220

2011 Audi A4.

Price $80

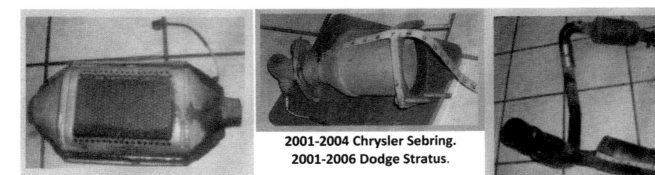

1997-1998 Jeep Wrangler.

2001-2004 Chrysler Sebring.
2001-2006 Dodge Stratus.

2004 Dodge Ram 1500.

Price: $85

Price: $60

Price: $60 ea.

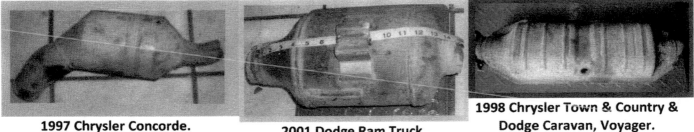

1997 Chrysler Concorde.
1996-1997 Dodge Intrepid.

2001 Dodge Ram Truck.

1998 Chrysler Town & Country &
Dodge Caravan, Voyager.

(Foil wrapped/Wire substrate)
(Weight trimmed: 4 Lbs.)
Price: $10 a Pound

Price: $125

(Flat 6 ribbed, center sensor)

Price: $240

2008 Dodge Caliber SRT 4.

2008 Dodge Caliber SRT 4.

1999 Jeep Cherokee.

Price: $50

Price: $50

(8" to 10")

Price: $85

1980 Chrysler Newport.
1987 Dodge/Plymouth Vans/Trucks
Dakota, Ram Truck.
1979-1987 Dodge/Plymouth
Vans/Trucks W Series.

Price: $20

2000 Jeep Wrangler.

Price: 7R: $90
8G: $60

2005 Dodge Ram Truck V10.

Price: $45

1992-1994 Dodge Daytona.
1990 Dodge Dynasty.
1993-1994 Plymouth Sundance,
Dodge Shadow.

Price: $55

2002-2003 Dodge Ram Truck 1500.

(Weight trimmed: 10 lbs.)

Price: $10 a Pound

2001 Dodge/ Plymouth
Vans/Trucks Durango.

Price: $90

1978 Plymouth Fury.

Price: $75

2001 Dodge/Plymouth Vans/Truck
Dakota
2000 Jeep Wrangler.

Price: $85

2004 Jeep Liberty.

Price: $65

1993-1995 Chrysler Concorde, Eagle, Vision. 1993-1995 & 1997 Dodge Intrepid.
1994 Chrysler Fifth Ave.
1994 & 1996 Chrysler LHS.
1994 & 1995 Chrysler New Yorker.

Price: $60

1980-1982 Chrysler LeBarron.
1981-1983 Chrysler Imperial.
1981-1989 Chrysler Fifth Ave.
1980-1983 Chrysler Cordoba.
1981-1991 Chrysler New Yorker.
1981 Chrysler Newport.
1979-1980 Dodge Aspen.
1981-1989 Dodge Diplomat.
1980-1983 Dodge Magnum.
1980-1983 Dodge Miranda.
1981 Plymouth Fury.

Price: $50

1994-1996 Dodge Ram 2500.

Price: $85

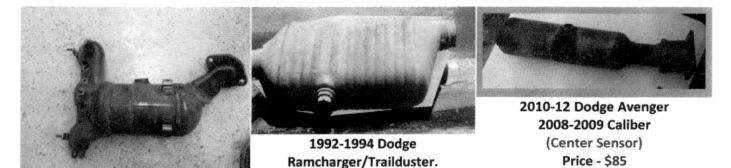

2007-2010 Chrysler Sebring.

Price - $50

1992-1994 Dodge Ramcharger/Trailduster.
1988-1991 Dodge W-Series.

(Side Air Pipe)

Price - $120

2010-12 Dodge Avenger
2008-2009 Caliber
(Center Sensor)
Price - $85

2000 Chrysler Cirrus.
1996-1997 & 1999-2000 Chrysler Sebring.
1997 Dodge Stratus.
001M: $90
080 A: $60
011 M: $90
011 A: $60
008 A: $125

1995 Dodge Stratus.
012A: $100

1998 Dodge Neon.
1995-1996 Dodge Stratus.
1996-1997 Plymouth Breeze.
855A: $60

Other Chrysler Numbers:
341 A: $60
009 A: $120
004 ABA: $120
008 ABA: $120
008 ABM: $150
009 ABA: $100
011 ABA: $100
011 ABM: $150
080 ABA: $50
080 M: $50
914 A: $100

1993-1994 Dodge Shadow.
1992 Chrysler Town & Country.
1993 Dodge Mini Ram Van, Caravan, Voyager.
1992-1994 Dodge Daytona.
Straight Edge/Straight Side Chrysler.

1993-1994 Plymouth Sundance.
746 A - $50
622 W - $50
732 W - $100

Other Numbers:
436 A - $70
622 A - $50
683 A - $50
683 W - $50
686 A - $50
686 W - $50
732 A - $90
732 M - $90
786 W - $70

1996-2000 Chrysler Town & Country.
1996-1999 Dodge/Plymouth Caravan, Voyager.
1996 Dodge Mini Van.
434 W: $50
435 ACA: $50
435 ACW: $80
435 ACS: $80
435 W: $80
436 A: $80
436 W: $80
436 ABA: $80

1993-1994 Plymouth Sundance.
746 A: $60
746 M: $50

2001 Dodge Neon.
303 A: $130

2001-2003 Dodge Neon.
674 A: $130

2001-2002 Dodge Neon.
979 AAA: $90

2003 Dodge Neon.
008 AAA: $50
008 ABA: $90

2005 Chrysler Sebring.
620 AEA: $100

2001-2004 Dodge Stratus.
633 ACA: $200
000 ABM: $90
000 ADM: $100
022 AAA: $200
023 AAS: $110
023 AFS: $110
394 AAM: $90
397 AAM: $110
439 AAM: $125

Other Numbers:

466 AAA: $120	645 A: $150	771 AAA: $120	925 ADA: $70
620 ADA: $120	674 A: $130	855 ABM: $120	979 A: $90
640 AAM: $220	674 AAM: $120	855 ACE: $90	

2003-2004 & 2006 Chrysler Town & Country.
2001-2005 Dodge Caravan & 2003 Voyager.
2005 Chrysler Pacifica.
637ACA: $90
637ACF: $90

Other Numbers:
031AAA: $130
031ABS: $110
031ACS: $90
031ADS: $110
617AAS: $100
631ADS: $90

2007 Dodge Ram. (5.7L)

Price: $65 ea.

T-Back

001M: $90
080 A: $60
011 M: $90
011 A: $60
008 A: $125
012A: $100
855A: $60
341 A: $60
009 A: $120
004 ABA: $120
008 ABA: $120
008 ABM: $150
009 ABA: $100
011 ABA: $100
011 ABM: $150
080 ABA: $50
080 M: $50
914 A: $100

13-Line

746 A - $50
622 W - $50

13-Line

732 W - $100
436 A - $70
622 A - $50
683 A - $50
683 W - $50
686 A - $50
686 W - $50

10-Line

434 W: $50
435 ACA: $50
435 ACW: $80
435 ACS: $80
435 W: $80
436 A: $80
436 W: $80
436 ABA: $80
746 A: $60
746 M: $50

Round Rib

771 AAA: $120
855 ABM: $120
855 ACE: $90

Round Rib

303 A: $130
674 A: $130
979 AAA: $90
008 AAA: $50
008 ABA: $90
620 AEA: $100
633 ACA: $200
000 ABM: $90
000 ADM: $100
022 AAA: $200
023 AAS: $110
023 AFS: $110
394 AAM: $90
397 AAM: $110
439 AAM: $125
466 AAA: $120
620 ADA: $120
640 AAM: $220
645 A: $150
674 A: $130
674 AAM: $120
925 ADA: $70
979 A: $90

Round Smooth

637ACA: $90
637ACF: $90
031AAA: $130
031ABS: $1100
031ACS: $90
031ADS: $110
617AAS: $100
631ADS: $90

Diesel

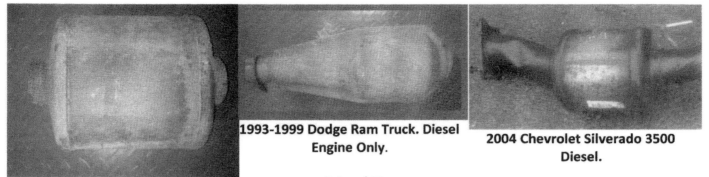

**1995 & 1997 E-Series.
1995-1997 Ford F-Series. Diesel
Engine Only.**

Price: $10

**1993-1999 Dodge Ram Truck. Diesel
Engine Only.**

Price: $15

**2004 Chevrolet Silverado 3500
Diesel.**

Price: $8

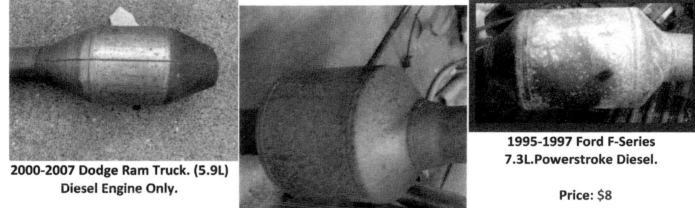

**2000-2007 Dodge Ram Truck. (5.9L)
Diesel Engine Only.**

Price: $20

2003-2004 Ford F-Series 6.0L Diesel.

Price: $8

**1995-1997 Ford F-Series
7.3L.Powerstroke Diesel.**

Price: $8

DPF

2007-Up Dodge Ram 6.7L. Cat NOx.
(Numbers engraved on case)
2196AAP- $620
3673AAC- $520
2196ABP- $420

2007-Up 2500 & 3500 Series, Dodge Ram 6.7L Particulate Filter.
(Numbers engraved on case)

2198AAP- $300
7113AAP- $80

2007-Up 3500 Series Dodge 6.7L Chassis.

Price: $270

2007-Up 2500-3500 Chevrolet/GMC Duramax 6.6L Particulate Filter.
(Numbers engraved on case)

12623221: $130
12602508- $270

2007-Up 2500-3500 Chevrolet/GMC Duramax 6.6L Particulate Filter.

Price: $250

2007-Up Ford F-Series 6.4L Cat/NOx.

Price: $200

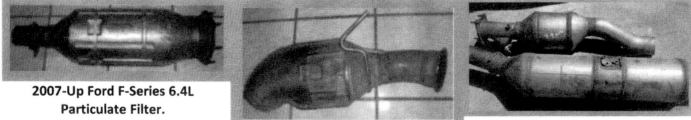

2007-Up Ford F-Series 6.4L Particulate Filter.

Price: $70

2007-Up Dodge Ram 6.7L. Particulate Filter.

Price: $140

2011-2012 Chevy Duramax 6.6L LML Filter & Cat NOx.

Top: $270
Bottom: $100

DPF

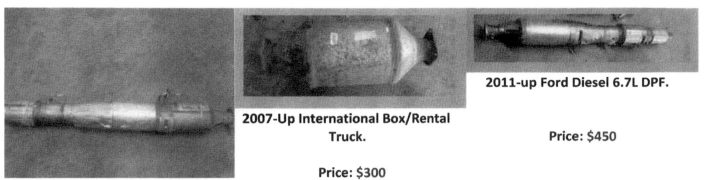

2011-Up Ford F-Series 6.7L Diesel.

Price: $550

2007-Up International Box/Rental Truck.

Price: $300

2011-up Ford Diesel 6.7L DPF.

Price: $450

2007 & Up Isuzu Complete.

(NOx/Filter Combo)

Price: $300

2012-up Dodge Ram 6.7L Combo.

(Small body Style)

Price: $200

Ford

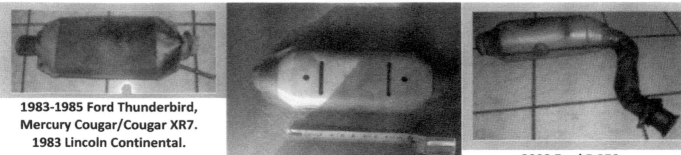

1983-1985 Ford Thunderbird, Mercury Cougar/Cougar XR7. 1983 Lincoln Continental.

Price: $50

2000 & 2006 Ford Mustang.

Price: $65

2008 Ford F-250. 2006 Ford Expedition.

Price: $90

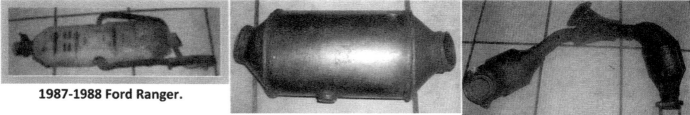

1987-1988 Ford Ranger.

(with air tubes)

Price: $50

2005 & 2007 Ford Mustang.

Price: $90

2000-2007 Ford Taurus. 2000-2005 Mercury Sable.

(No shield)

Price: $75 ea.

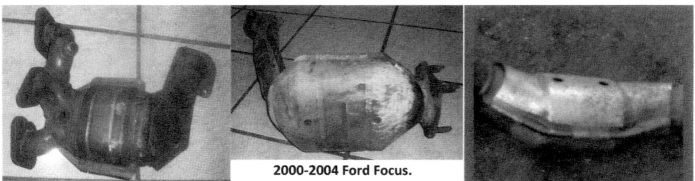

2000-2005 Mercury Sable, Ford Taurus.

Price: $20

2000-2004 Ford Focus.

(4 bolt flange)

Price: $100

1999-2004 Ford Mustang.

Price: $52

Ford

1999 Ford Cobra
1986-1995 Ford Mustang.
1983-1991 Ford Crown Victoria.
1986-1987 Ford LTD.
1986-1990 Lincoln Town Car, Grand Marquis.
1986-1991 Lincoln Continental.
1986-1992 Lincoln Mark, Mercury Capri.

Price: $20

1994-1997 Ford Contour.

No Air Pipe: **$110**
With Air Pipe: **$100**

1986-1988 Ford Bronco. 1986-1987 Ford Bronco ll, Ranger.

Price: $30

2000-2004 Ford Explorer.
2000-2003 Mercury Mountaineer.
2001-2003 Ford Ranger.

Price: $45 ea.

1992-1997 & 1999 & 2001-2002 Ford Crown Victoria. 1990, 1994, 1997-2002 Lincoln Town Car. 1994-2002 Mercury Grand Marquis.

Price: $65

1992-1996 & 2001-2002 Ford Crown Victoria. 1990, 1994, 1994 & 2001-2002 Lincoln Town Car. 1994-1997 & 1999-2002 Mercury Grand Marquis.

Price: $85

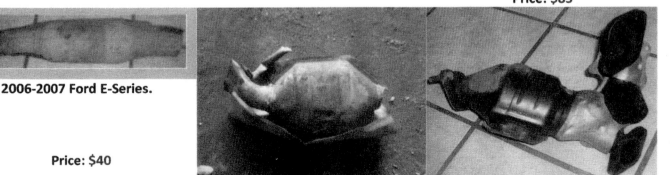

2006-2007 Ford E-Series.

Price: $40

1984-1986 Ford E-Series, F-Series.
1983-1986 Ford Bronco.

Price: $35

2001-2008 Ford Escape.

Price: $25

Ford

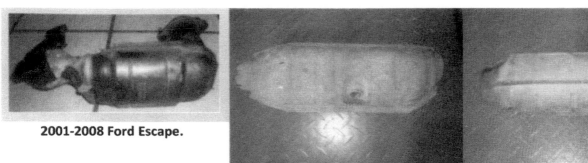

2001-2008 Ford Escape.

Price: $20

1999-2001 Ford Expedition, F-Series.

(with center sensor hole)

Price: $55

2002-2005 Ford Explorer.
2002-2003 Mercury Mountaineer.

Small Cells $60 (Made ¾)
Big Cells $115 (Made ¾)

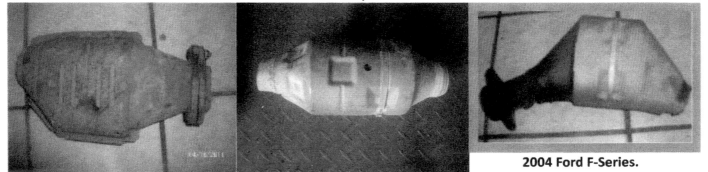

2004-2005 Ford Ranger.

Price: $65

2004 Ford F-Series.

Price: $45

2004 Ford F-Series.

(3 Squares)

Price: $100

2000-2002 Jaguar S-Type.
2000-2002 Lincoln LS.
2002 Ford Thunderbird.

Price: $100

2006 Ford Fusion.

(3 sensor holes)

Price: $110

1996-1999 Ford Mercury Sable.

Price: $50

Ford

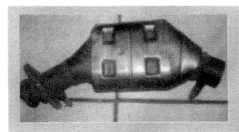

**2003 & 2006 Lincoln Navigator.
2002-2005 Ford. Expedition.
2002 Ford F-Series.**

Price: $80

**2003 & 2006 Lincoln Navigator.
2002-2005 Ford. Expedition.
2002 Ford F-Series.**

Price: $25

1988-1995 Ford E-Series, F-Series.

(Old Torpedo w/Flange and air tube)

Price: $40

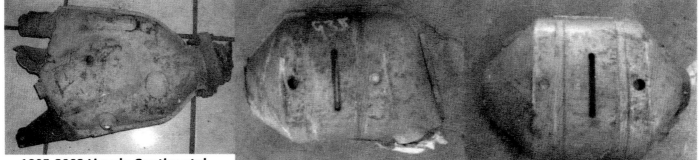

1995-2002 Lincoln Continental.

Price: $60

1995-2002 Lincoln Continental.

Price: $80

1995-2002 Lincoln Continental.
(fat stop sign)
Price: $110

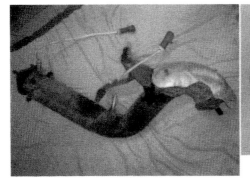

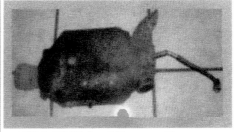

2002 & 2004 Ford Focus.

(Weight trimmed: 8 Lbs.)

Price: $8 a Pound

2003-2004 Lincoln Aviator.

Price: $40

**1986-1993 Ford Taurus, Tempo
Mercury Sable.**

(Scorpion w/Sensor)

Price: $90

2003-2004 Lincoln Aviator.

Price: $45

2002-2004 Ford Explorer.
2002-2003 Mercury Mountaineer.

Made Full Price: $125
Made Half Price: $85

1995-2000 Ford Windstar.

Price: $50

2003-2006 Ford Crown Victoria.
2003-2004 Lincoln Town Car.
2003-2005 Mercury Grand Marquis.
2004 Mercury Marauder.

Factory Full Price: $55
Factory Half Price: $30

1997-2004 Ford expedition.
1999-2000 Ford F150.
1998 Lincoln Navigator.

(Case smooth on both sides)

Price $95

1987-1995 Ford Escort. (1.9L)

(Ford Spoon)

Price: $40

2001-2002 Ford Excursion.
1997-2007 (5.4L & 6.8L only) Ford E-Series.
1999-2003 (6.8L only) Ford F-Series.
(No air tubes)
Torpedo Numbers:
F81A: $400
F7UA: $350
F7TA: $325
F5TA: $310
F81D: $285
4C24: $280
2C3C: $270
YC25: $200
YC2C: $200
7C24: $150
1C2C: $150
2C2C: $150
F4TA: $100
5C34: $90

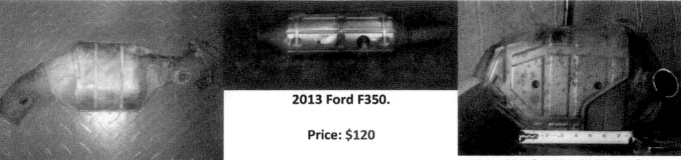

2013 Ford F350.

Price: $120

2003-2006 Ford Crown Victoria.
2003-2004 Lincoln Town Car.
2003-2005 Mercury Grand Marquis.
2004 Mercury Marauder.

Price: $70

1998-1999 & 2001-2003 Ford Escort.
2.0L DOHC.

New Spoon Part Numbers Begin
with:
X-$195
F-$115
1-$85
2-$90

2000-2007 Ford Taurus.
2000-2005 Ford Sable.
(w/shield)

Price: $75

1997-2001 Ford Expedition.
1996-2003 Ford F-Series. E-Series.
1998 Lincoln Navigator.

Price: $60

1994-2002 & 2004 & 2006 Ford Mustang.
1999 Ford Cobra.

Price: $50

2001-2002 & 2004 Ford Ranger.

Price: $45

2006 Mercury Monterey.
2001-2002 Ford Windstar.

Price: $115

2006 Mercury Monterey.
2001-2002 Ford Windstar.

Ford: $85

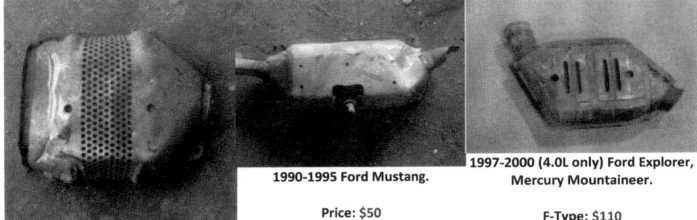

1988-1993 Ford Ranger.
1988-1992 Ford Bronco 2.
1991-1992 Ford Explorer.
1990-1992 Mazda Navajo.

Price: $35

1990-1995 Ford Mustang.

Price: $50

1997-2000 (4.0L only) Ford Explorer, Mercury Mountaineer.

F-Type: $110
X-Type: $150

1975-1979 Ford Futura. (5.0L)
1980-1981 Ford Futura. (4.2L)
1978-1984 Ford Futura. (3.3L)

Price: $30

1975-1976 Ford Granada.
1975-1979 Ford LTD.

Price: $20

2005 Ford F-250 & F-350 (5.4L only)

Price: $75

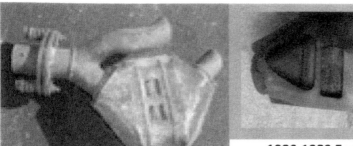

1989 Ford Tempo. (3.0L)
1990 Ford Taurus. (3.0L)
1988-1990 Ford Taurus. (2.8L)

Price: $20

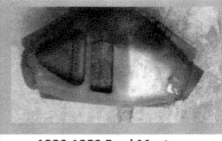

1986-1989 Ford Mustang.
1986-1992 Mercury Capri.

(Cutout Shield)

Price: $45

1980 Ford LTD, Lincoln Continental,
Versailles, Mercury Grand Marquis.

(Cutout Shield)

Price: $45

1997-2000 (4.0L only) Ford Explorer,
Mercury Mountaineer.
F–Type $110
X-Type $150

2006-2007 Ford Focus.

Price: $65

2005 Ford Five Hundred.
2005-2007 Ford Freestyle.
2005-2007 Murcury Montego.

Price: $60

1991-1994 Ford Tempo.

(3 Dot Cigar)

Price: $95

2001 Ford Focus

Price: $120

(Small Mouth Ford)
(Center Sensor)

1993 Chevrolet S10, S15, T10, T15, Sonoma.
1987-1993 Chevrolet 1500, 2500, 3500.

(Round)

Price: $120

1991-1992 & 1994 Cadillac Seville.
1994-1995 Cadillac Deville.
1991-1992 Cadillac EL Dorado.

(6-Dot)

25145126: $180
25145124: $100
25145130: $90

1996-1999 Chevrolet 2500/3500.

(Big GM AC)

25160620: $100

2000-2002 Chevrolet Astro/Safari.
(454)
25311944: $230
25326305: $130
25161492: $80

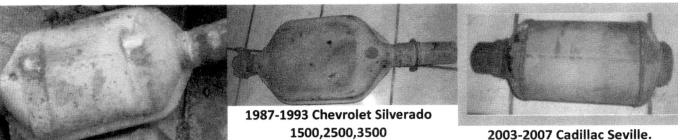

1987-1993 Chevrolet Silverado 1500,2500,3500
Blazer, Jimmy, Jumbo Bead – Pellet 26 in.
3 in. Pipe

(Must be Shaken or weighed 28+Lbs full)

Price: $90

2003-2007 Cadillac Seville.

Price: $140

2004-2006 Chevrolet Trail Blazer.
2004-2005 GMC Envoy, Buick Rainer.

Price: $100

2007-2010 Chevrolet Corvette.

Price: $25

2010-2012 Chevrolet 1500.

Price: $40

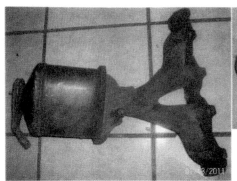

**2004-2006 Chevrolet Malibu.
2006 Pontiac G6.**

Price: $90

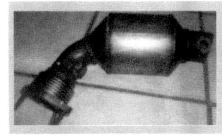

**1985-1989 Geo Spectrum. 1989-1992
Geo Storm. 1982-1993 Isuzu Impulse.
1990 & 1993 Isuzu Stylus.**

Price: $85

**2004 Chevrolet Aveo.
2006 Chevrolet Equinox.
2006 Suzuki Forenza.**

Price: $60

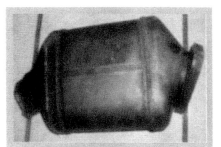

**1998-2002 Chevrolet Camaro,
Pontiac Firebird/Trans AM.**

Price: $90

2007-2010 Chevrolet Corvette.

Price: $50

**1995-1999 Chevrolet S10.
1995 Chevrolet S15, T10, T15.
1995 & 1998 Chevrolet Sonoma.**

(2514-up w/AC Stamped on shield)

Price: $120

2012 Chevrolet Malibu

(w/Flange)

Price: $70

2006 Buick Rendezvous.
2004 Pontiac Aztec.
2002 & 2004 Chevrolet Venture.

(Crimped Ends)

Price: $85

2003-05 Cadillac CTS.

Price: $60

2009 Cobalt SS.

Price $60 ea.

1999-2000 Cadillac Catera.
25179756: $170
25179755: $170

1997-1998 Cadillac Catera.
25160508: $80
25160509: $80

Other Numbers:
12576374: $80
25325249: $150
25325254: $90
25325250: $150

(ribbed or smooth case)

2006 Suzuki Forenza.

Price: $50

1997-2001 Geo Prism.

Price $50

1981-1987 Chevrolet Monte Carlo.
1982-1993 Chevrolet Impala.
1983-1987 Chevrolet Caballero.
1984-1987 Oldsmobile 98, Cadillac Seville, Cadillac Dorado, Deville, Limousines.

1984-1992 Cadillac Fleetwood, Oldsmobile Delta 88.
1984-1993 Chevrolet Caprice.
1982-1984 Buick Skylark.
1982-1985 Chevrolet Celebrity, Pontiac Firebird/Trans Am.

1981-1985 Chevrolet Citation.
1984 Buick Park Ave.
1983-1988 Oldsmobile Cutlass.
1983-1986 Pontiac Bonneville.
1981-1982 & 1987 Pontiac Grand Prix.
1982 Pontiac Phoenix, Ventura II.
1981-1993 Pontiac Firebird/Trans AM.

1982-1987 Buick Century.
1982-1992 Oldsmobile Ciera.
1985 & 1991 Pontiac 6000.
1980-1987 Buick Regal.
1984-1985 Chevrolet Corvette, Buick Electra- Rear WD, Le Sabre.
1983-1992 Chevrolet Camaro.

(Air Tube GM)

Price: $80

2003 Chevrolet Trailblazer, GMC Envoy, Isuzu Ascender.
2003-2005 Chevrolet 1500.
2004 Cadillac Escalade.
2004 & 2007 Chevrolet 1500.
2004 Buick Rainer.
2006 Chevrolet Trailblazer
2002 Cadillac Escalade.
2004 Chevrolet 1500.
12573754: $40

2007 Chevrolet 1500.
2008 GMC Sierra.
12575511: $20
12600806: $40
12575512: $20

2003-2005 Chevrolet 1500
12573361: $30
12571920: $60
12573754: $40

2006 Chevrolet Impala.
12596678: $60

1998-2002 Chevrolet Camero/Pontiac Firedbird/Trans AM.
25313499: $120
25163203: $60
25163198: $60

2007 Chevrolet Colorado.
2006 Hummer H3.
12593013: $20

2004-2005 Chevrolet Malibu.
12576584: $60

1996-2000 Chevrolet Full Size Van.
25153032: $50

2006 Chevrolet Impala.
12596678: $60

Other Oval Numbers:

12607440: $70	25362095: $50	12575300: $60	12596906: $30
12574249: $30	12575299: $50	25152589: $80	
12579935: $70	25153080: $100	12622977: $50	
12574396: $90	15786790: $50	12604241: $30	
12575939: $200	12569368: $40	12619965: $80	
12607439: $70	12569367: $20	12585308: $60	
12585307: $40	25146440: $90	12622978: $50	
25163203: $60	12610079: $50	25146441: $80	
12603569: $40	12594179: $40	12608179: $30	
12595068: $120	12610078: $60	12607439: $70	

(Oval Shaped)

2002 Cadillac Escalade.
2001 & 2003 Chevrolet 1500.
2002-2003 Hummer H2.
25312626: $80
25179829: $40

1998 Chevrolet 1500.
25177735: $80
25180199: $80

1999-2002 Chevrolet 1500
2001-2009 Chevrolet Full Size Van.
25318379: $40
25319109: $20
25318376: $80

Other Chevrolet Silverado Numbers:
12570786: $40
25339082: $40
93429561: $30

(Small round body FLOW)

2003 Chevrolet Full Size Fan(4.8L 2500 only)
12568994: $75

2003 chevrolet 1500 SS
2001 Chevrolet 6500.
2004 Chevrolet 3500.
2006 GMC Savannah.

--

Other Numbers:
12603927: $75
12570477: $50
12573730: $50
12573926: $70
12580906: $50
25317923: $215
25328019: $215
25328022: $125
25328025: $185
25362147: $65

1989-1993 Buick Century.
1990 Chevrolet Celebrity/Eurosport/Oldsmobile Cutlass.
1993 Oldsmobile Ciera.
25127732: $75
25128319: $60

1990 Chevrolet Celebrity/Eurosport.
1992 Chevrolet Lumina.
1993 Oldsmobile Cutlass/Pontiac Grand Prix.
25129048: $70

1990 Chevrolet Eurosport.
1994 Oldsmobile Ciera.
25145485: $125

1994 & 1996 Oldsmobile Ciera.
1990-1991 Buick Skylark.
25160502: $125

1990-1991 Buick Regal.
1990 Chevrolet Celebrity/Eurosport.
25128998: $75
25128983: $65

1989-1991 Buick Skylark.
1995 Chevrolet Beretta.
1990-1995 Chevrolet Cavalier/Pontiac J2000/Sunfire.
1993-1994 Chevrolet Corsica.
1990-1991 Pontiac Grand AM.
1990-1992 Saturn.
25145314: $120
25127553: $45

1996 Chevrolet Corsica.
1990-1992 Saturn.
25161266: $130

1996 Chevrolet Sonoma.
25152988: $145

1 of 2

2001 Daewoo Lanos.
96282703: $100

1993-1996 & 1999 Saturn.
25178577: $135
25146473: $55

2000 Daewoo Nubria.
2001 Daewoo Lanos/Leganza.
96350079: $70

2001 Daewoo Leganza.
2000 Daewoo Nubria.
96273660: $90

1996-1998 Chevrolet Cavalier/Pontiac Sunfire.
1997 Pontiac J2000.
1990-1992 Saturn.
25317334: $140
25317333: $130
25160523: $135

Other 4-Dot Numbers:
25316547: $180
25165123: $145
25177514: $120
25163564: $115
25149914: $110
25130353: $75
25130333: $70
25129073: $70
25145371: $65
25143015: $65
25127259: $65
25128981: $60
25145643: $60
25140473: $50
25143452: $50
25152641: $50
25144261: $50
25143990: $50
25103078: $45
25103080: $45

2 of 2

2000-2001 Oldsmobile Aurora.
25324392: $85

1992 Pontiac Grand Prix.
1993-1994 Oldsmobile Achieva.
1993-1995 Buick Skylark/Pontiac Grand AM.
25144158RU: $95
25143634RW: $85
25130776DZ: $75

1994-1995 Buick Skylark/Oldsmobile Achieva/Pontiac Grand AM.
1995 Chevrolet Beretta/Corsica.
1996 Oldsmobile Toronado.
10219956SK: $85

1995-1996 Buick Skylark
1996 Chevrolet Beretta/Corsica/Pontiac Grand AM.
10243261TC: $85

1996-1997 Buick Skylark
1996-1998 Oldsmobile Achieva/Pontiac Grand AM.
25160529PP: $85

1996-1998 Chevrolet Cavalier/Pontiac Sunfire.
1997-1998 Chevrolet Malibu.
1999 Pontiac Grand AM.
1996 Pontiac J2000/Pontiac Sunbird.
25160527JY: $85
25317335: $75

1997-1998 Buick Skylark/Pontiac Grand AM.
1998 Oldsmobile Achieva.
24506041SN: $85
24507292NN: $85

1996-1997 Buick Skylark/Pontiac Grand AM.
1996-1998 Oldsmobile Achieva.
25160531RR: $85

1997-2000 Chevrolet Malibu.
1999-2000 Oldsmobile Alero.
1998-1999 Oldsmobile Cutlass.
24507193PN: $85
24508309NT: $85
24507291NT: $85

1999 Pontiac Grand AM.
24508310NC: $195
12563202LT: $195
24507564: $175

1999-2000 Pontiac Grand AM.
12563203XX: $195
24508419JF: $65

1999 Pontiac Grand AM.
12563202LT: $195
24508312: $160

1995 Buick Century.
1994-1995 Oldsmobile Cutlass.
25143598ND: $75

1996 Buick Century/ Oldsmobile Cutlass.
24503701XA: $85

1995-1996 Chevrolet Lumina.
1994-1996 Pontiac Grand Prix.
24504613KR: $85

1994-1995 Buick Regal.
25144762LX: $195

1994 Buick Regal.
1995 Chevrolet Monte Carlo/ Oldsmobile Cutlass.
25131821MF: $85

1998 Chevrolet Impala.
1997-1999 Chevrolet Monte Carlo.
1996-2000 Chevrolet Lumina.
1997 Oldsmobile Cutlass.
24508105: $165
24506982AJ: $90
24508104FL: $90
24506761: $90
12563310: $80

1998 Chevrolet Lumina/Monte Carlo.
25178562: $175

1996 Chevrolet Lumina
25162377: $95

1998-1999 Chevrolet Lumina.
25165306: $90

1998 Buick Regal.
1997 & 1999 Pontiac Grand Prix.
25326042: $160
24505514: $95

2 of 4

40

1996-1997 Pontiac Trans Sport.
2001 Chevrolet Venture Van/Pontiac Montana/Pontiac Trans Sport.
1997 Pontiac Ventura.
25180114: $195
25176615: $195
25322854: $160
25160636: $90

1997 Oldsmobile Cutlass.
1997-1999 Pontiac Grand Prix.
1998 Oldsmobile Intrigue.
1998-1999 Buick Regal.
24507880: $195
24507888: $195
24507889: $90
24505512: $85

1997 Pontiac Grand Prix.
2000 Chevrolet Monte Carlo/Impala.
1997-2000 Chevrolet Lumina.
1997-2000 Buick Century.
12563201: $155
24508103: $195
24506980: $165
24506982: $185
24507885: $90
24507887: $85
24508102: $90

1999-2002 Oldsmobile Intrigue.
24505514: $90
25324393: $90
25317396: $90

2001-2003 & 2005 Buick Century/Chevrolet Impala.
2001-2003 Chevrolet Monte Carlo.
2000-2003 Pontiac Grand Prix.
25325228LH: $95

1998 Oldsmobile Silhouette/Pontiac Montana.
1996-1998 Pontiac Trans Sport.
25172258: $160

3 of 4

10219956: $195	12582330: $155	24506041MF: $75	24507417: $75	24508910NC: $19?
10243261: $155	12596535: $195	24506761: $90	24507881: $90	24586841TC: $75
10243261XA: $75	12598222: $195	24506761NC: $195	24507881KR: $75	25122258: $175
12563200: $195	12612779: $90	24506841SN: $75	24507885AB: $90	25122258LT: $195
12563200TC: $75	24500114: $75	24506936: $195	24507885PN: $75	25130776NT: $75
12563201RU: $90	24503701: $195	24506980RY: $75	24507889BD: $90	25130776SK: $75
12563201SN: $75	24503825AS: $75	24506982: $195	24507889XX: $155	25131709: $90
12563202AJ: $90	24503880: $195	24507193: $90	24508102: $90	25176479: $185
12563203ND: $65	24504613: $75	24507291NI: $75	24508103FL: $65	25130776: $65
12563310DZ: $65	24504613FL: $65	24507291RR: $75	24508104: $90	25130778: $90
12563310FL: $75	24505512RW: $75	24507292: $75	24508309NC: $195	25130781: $65
12563310JY: $75	24506041: $90	24507292FL: $75	24508309NI: $75	25130781NT: $75
12563311: $90	24506041FH: $65	24507417FL: $75	24508310: $175	25131709SN: $75
25131790: $75	252143636RX: $65	25160531: $75	25169565ND: $65	25317336: $90
25131790AJ: $90	252143637: $65	25160636ND: $65	25169587: $90	25317336PP: $75
25131790FH: $65	252143637FL: $75	25160658: $195	25172258AS: $75	25317905: $195
25131821: $175	252143637RY: $75	25160732: $90	25176479JY: $90	93427523: $65
25131821KR: $75	25143639: $75	25160732RU: $90	25176615JY: $90	
25142598ND: $65	25143639AS: $75	25161303: $90	25177258: $90	
25143588: $65	25144158NN: $75	25162377JY: $90	25177615: $65	
25143596ND: $65	25144158SN: $75	25162377RR: $75	25180114FL: $75	
25143598JF: $65	25144762: $195	25163794: $75	25313011: $195	
25143598: $195	25160521: $90	25163794PP: $75	25315335: $90	
25143598ND: $75	25160527: $75	25165595: $175	25316458: $175	
25143598XA: $75	25160527FJ: $75	25165595MF: $75	25316458FL: $75	
252143636FL: $75	25160529: $90	25169538RW: $75	25317335JY: $75	

25179076: $295

2000-2001 Chevrolet Jimmy 2dr/Blazer 2dr.
25325537: $100

2001-2002 Chevrolet S10 2dr.
25316631: $185
25326304: $85

1994-1995 Chevrolet 1500.
1994 Chevrolet Blazer/Safari/Sonoma/S15/T10/T15.
25145198: $65
25146767: $75

1995 Chevrolet Astro.
1995 Chevrolet Caballero/EL Camino.
1994-1995 Chevrolet Safari.
25144275: $70

1996-1998 Chevrolet 1500.
25162254: $75
25312170: $85
25312171: $100

1996-1999 Chevrolet Astro/Safari.
25153034: $75

1995 Chevrolet Full Size Fan.
25144333: $75

1996-2002 Chevrolet Full Size Fan (4.3L & 5.0L only).
25152823: $70

1993-1995 Chevrolet Blazer/Jimmy 4.3L.
1995 Chevrolet S10/S15/Sonoma/T10/T15 4.3L.
25160212: $100

1996-1999 Chevrolet Blazer/Jimmy.
1996 & 1998 Oldsmobile Bravada.
25152880: $90
25175248: $215
25314445: $100
25325537: $100
25152879: $90

Other Numbers:
25161908: $85
25145138: $65
25316637: $235
25316635: $220
25314447: $220
25152879: $90
25314444: $70
25325538: $105
25325536: $100

2001 Saturn 2.2L.
2000-2003 Saturn 2.2L.
2003 Saturn L 200 2.2L.
25170991: $160
25325912: $190

1999 & 2001 Oldsmobile Alero 2.2L.
1999-2000 Chevrolet Caliver 2.4L.
1999 Chevrolet Malibu 2.4L.
1999 & 2001 Pontiac Grand AM 2.4L.
2000 Pontiac SunFire 2.4L.
25321134: $170
25321133: $60
22667029: $160

2003-2004 Chevrolet Cavalier 2.2L.
2004 Chevrolet Malibu 2.2L.
2002-2003 Oldsmobile Alero 2.2L.
2002 Pontiac Grand AM 2.2L.
2004 Pontiac Sunfire 2.2L.
22676850: $160
22712077: $60

Other Numbers:
15141629: $60
93439667: $85

2000-2002 Chevrolet S10.
2000 Chevrolet Sonoma.
12568312: **$180**
25324609: **$200**

1999-2001 Chevrolet Cavalier.
1999 Pontiac J2000, Sunbird.
1999-2000 Pontiac Sunfire.
25178565: **$70**
25178566: **$200**
22667030: **$160**

Other Large Flow Numbers:
25325911: **$140**
93433567: **$100**

2005-2006 Buick Rendezvous.
2003 Pontiac Montana.
2002& 2004 Chevrolet Venture Van.
2004 Pontiac Aztec.
12564250: $120
12570900: $130
12574994: $135
25325233: $120
25325228: $70
10301642: $100

2001-2003 Chevrolet Malibu/Oldsmobile Alero/Pontiac Grand AM.
25325206: $130
22685816: $120
22712078: $140

2001-2004 Buick Regal.
2001-2001 Chevrolet Impala/Monte Carlo/Pontiac Grand Prix.
25325231: $130

1999-2002 Oldsmobile Intrigue.
25313011: $200

2004 Cadillac Deville.
12572103: $120

Other Numbers:
25325208: $130

1996-1998 Honda Passport.
1997 Isuzu Rodeo.
25164762: $70

1996-1999 Honda Passport.
1998 Isuzu Amigo.
1997-2002 & 2004 Isuzu Rodeo.
25167657: $70
25167662: $120

1996-1998 Honda Passport.
1997 Isuzu Rodeo.
25320474: $120

1998-1999 Honda Passport.
1998 Isuzu Amigo
1998-2002 & 2004 Isuzu Rodeo.
25314587: $120

Other Numbers:
25164774: $130

1996-2000 Chevrolet Full Van 5.7L.
1999-2000 Cadillac Escalade 5.7L
1996-2000 Chevrolet 1500 5.7L
1997 Chevrolet Blazer/Jimmy 5.7L

25153032: $50

2002-2003 Chevrolet Envoy.
Trailblazer.
2001-2003 GMC Envoy.
2002 Oldsmobile Bravada.
2003 VW Envoy.

Price: $85

1996 Buick Roadmaster/Chevrolet
Impala.

25153057: $80
25153052: $80

6-Dot
25145126: $180
25145124: $100
25145130: $90

Big GM AC
25160620: $100

454
25311944: $230
25326305: $130
25161492: $80

Catera
25179756: $170
25179755: $170
25160508: $80
25160509: $80
12576374: $80
25325249: $150
25325254: $90
25325250: $150

Ovals
12576584: $60
25153032: $50
12596678: $60
12574249: $30
12579935: $70
12574396: $90
12575939: $200
12607439: $70
12585307: $40
25163203: $60
12603569: $40
12595068: $120
12607440: $70
25362095: $50
12575300: $60
12596906:$30
12575299: $50
25153080: $100
15786790: $50
12569368: $40
12569367: $20
25146440: $90
12610079: $50

Ovals
12594179: $40
12610078: $60
25152589: $80
12622977: $50
12604241: $30
12619965: $80
12585308: $60
12622978: $50
25146441: $80
12608179: $30
12607439: $70
12607440: $70
25362095: $50
12575300: $60
12596906: $30
12573754: $40
12575511: $20
12600806: $40
12575512: $20
12573361: $30
12571920: $60
12573754: $40
12596678: $60

Ovals
25313499: $120
25163203: $60
25163198: $60
12593013: $20

6.0 Pills
12568994: $75
12603927: $75
12570477: $50
12573730: $50
12573926: $70
12580906: $50
25317923: $215
25328019: $215
25328022: $125
25328025: $185
25362147: $65

Small Flows
25312626: $80
25179829: $40
25177735: $80
25180199: $80
25318379: $40
25319109: $20
25318376: $80
12570786: $40
25339082: $40
93429561: $30

4-Dot
25127732: $75
25128319: $60
25129048: $70
25145485: $125
25160502: $125
25128998: $75
25128983: $65
25145314: $120
25127553: $45
25161266: $130
25152988: $145
96282703: $100
25178577: $135
25146473: $55
96350079: $70
96273660: $90
25317334: $140

4-Dot
25317333: $130
25160523: $135
25316547: $180
25165123: $145
25177514: $120
25163564: $115
25149914: $110
25130353: $75
25130333: $70
25129073: $70
25145371: $65
25143015: $65
25127259: $65
25128981: $60
25145643: $60
25140473: $50
25143452: $50

4-Dot
25144261: $50
25143990: $50
25103078: $45
25103080: $45
25152641: $50

Large Flow
12568312: $180
25324609: $200
25178565: $70
25178566: $200
22667030: $160
25325911: $140
93433567: $100

RoundLoaf
25170991: $160
25325912: $190
25321134: $170
25321133: $45
22667029: $16
22676850: $160
15141629: $55
93439667: $85

Tahoe

25179076: $295	25152880: $90
25325537: $100	25175248: $215
25316631: $185	25314445: $100
25326304: $85	25325537: $100
25145198: $65	25152879: $90
25146767: $75	25161908: $85
25144275: $70	25145138: $65
25162254: $75	25316637: $235
25312170: $85	25316635: $220
25312171: $100	25314447: $220
25153034: $75	25152879: $90
25144333: $75	25314444: $70
25152823: $70	25325538: $105
25160212: $100	25325536: $100

Small Breadloaf

12564250: $120
12570900: $130
12574994: $135
25325233: $120
25325228: $70
10301642: $100
25325206: $130
22685816: $120
22712078: $140
25325231: $130
25313011: $200
12572103: $120
25325208: $130

Triangle

25164762: $70
25167657: $70
25167662: $120
25320474: $120
25314587: $120
25164774: $130

Breadloaf

25324392: $85
25144158RU: $95
25143634RW: $85
25130776DZ: $75
10219956SK: $85
10243261TC: $85
25160529PP: $85
25160527JY: $85
25317335: $75
24506041SN: $85
24507292NN: $85
25160531RR: $85
24507193PN: $85
24508309NT: $85
24507291NT: $85

Breadloaf

24508310NC: $195
12563202LT: $195
24507564: $175
12563203XX: $195
24508419JF: $65
12563202LT: $195
24508312: $150
25143598ND: $75
24503701XA: $85
24504613KR: $85
25144762LX: $185
25131821MF: $85
24508105: $165
24506982AJ: $90
24508104FL: $90
24506761: $90
12563310: $80
25178562: $175
25162377: $95
25165306: $90
25326042: $160
24505514: $95

Breadloaf

10219956: $195	12582330: $155	24506041MF: $75
10243261: $155	12596535: $195	24506761: $90
10243261XA: $75	12598222: $195	24506761NC: $195
12563200: $185	12612779: $90	24506841SN: $75
12563200TC: $75	24500114: $75	24506936: $185
12563201RU: $90	24503701: $195	24506980RY: $75
12563201SN: $75	24503825AS: $75	24506982: $195
12563202AJ: $90	24503880: $195	24507193: $90
12563203ND: $65	24504613: $75	24507291NI: $75
12563310DZ: $65	24504613FL: $65	24507291RR: $75
12563310FL: $75	24505512RW: $75	24507292: $75
12563310JY: $75	24506041: $90	24507292FL: $75
12563311: $90	24506041FH: $65	24507417FL: $75

Breadloaf

24507881: $90	24508310: $165	25130778: $90	25142598ND: $65	252143637FL: $75
24507881KR: $75	24508910NC: $195	25130781: $65	25143588: $65	252143637RY: $75
24507885AB: $90	24586841TC: $75	25130781NT: $75	25143596ND: $65	25143639: $75
24507885PN: $75	25122258: $165	25131709SN: $75	25143598JF: $65	25143639AS: $75
24507889BD: $90	25122258LT: $195	24508309NI: $75	25143598: $185	25144158NN: $75
24507889XX: $155	25130776NT: $75	25131790: $75	25143598ND: $75	25144158SN: $75
24508102: $90	25130776SK: $75	25131790AJ: $90	25143598XA: $75	25144762: $185
24508103FL: $65	25131709: $90	25131790FH: $65	252143636FL: $75	25160521: $90
24508104: $90	25176479: $195	25131821: $165	252143636RX: $65	25160527: $75
24508309NC: $195	25130776: $65	25131821KR: $75	252143637: $65	25160527FJ: $75

Breadloaf

25160529: $90

25160531: $75

25160636ND: $65

25160658: $195

25160732: $90

25160732RU: $90

25161303: $90

25162377JY: $90

25162377RR: $75

25163794: $75

25163794PP: $75

25165595: $175

25165595MF: $75

25169538RW: $75

Breadloaf

25169565ND: $65

25169587: $90

25172258AS: $75

25176479JY: $90

25176615JY: $90

25177258: $90

25177615: $65

25180114FL: $75

25313011: $195

25315335: $90

25316458: $175

25316458FL: $75

25317335JY: $75

25317336: $90

Breadloaf

25317336PP: $75

25317905: $195

93427523: $65

Honda

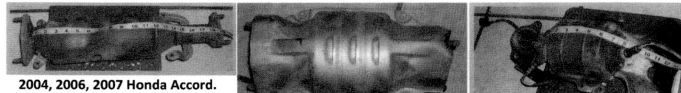

**2004, 2006, 2007 Honda Accord.
2003 Acura TSX, 2005 Acura RSX.**

(3 Bolt Flange, Center sensor)

Price: $130

**2003 & 2005 Acura MDX.
2005 Honda Pilot.
2006 Honda Odyssey.**

Price: $45

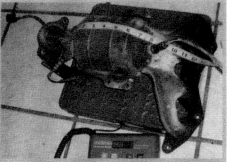

**2001-2002 Honda Civic
2004-2005 Honda Civic.**

Price: $115

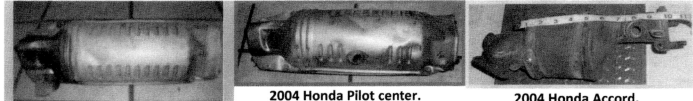

**1988 Honda CRX.
1999 & 2001 Honda Prelude.**

Price: $140

2004 Honda Pilot center.

(Center Sensor Slant)

Price: $200

**2004 Honda Accord.
2006-2007 Honda Pilot.
2006-2008 Honda Ridgeline.
2005 Acura MDX.**

Price: $45

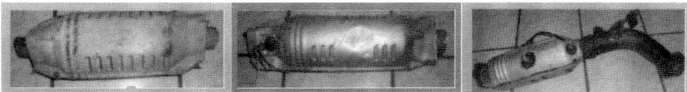

**1988 Honda CRX.
1993 & 1998-2000 Honda Accord.**

(8 Vents)

Price: $80

**1997-1999 Acura CL. 1999-2003
Acura TL.
1995-2001 Honda Accord. 1988
Honda CRX.**

(10 Vents/End Sensor)

Price: $140

**2002-2003 Honda Civic, RSX, CRV.
Center & Top o2.**

(Full shield)
(Fat Pipe)

Price: $260

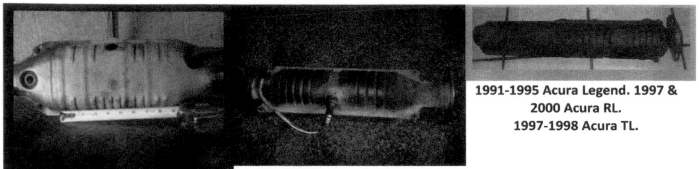

1996-1997 & 2001 Acura Integra.

Price: $100

1999-2000 Honda Civic EX.

Price: $190

1991-1995 Acura Legend. 1997 & 2000 Acura RL.
1997-1998 Acura TL.

Price: $185

2006 Honda Civic.

Price: $90

1998-2001 Honda CRV.
2000 Acura Integra
1998 Isuzu Oasis.

Price: $110

2000 Acura RL.

(Weight trimmed 11 Lbs.)

Price: $12 a Pound

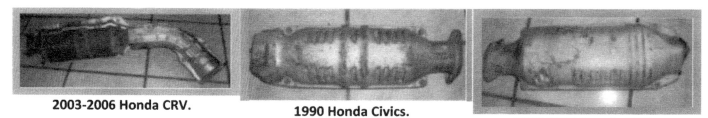

2003-2006 Honda CRV.

(Half Shield)
(Small Pipe)

Price: $180

1990 Honda Civics.
1998 Isuzu Oasis.
1995-1996 Honda Accord.
1988 Honda CRX.

Price: $70

1998-2001 Honda CRV.

(10 Vents/no sensor)

Price: $110

Honda

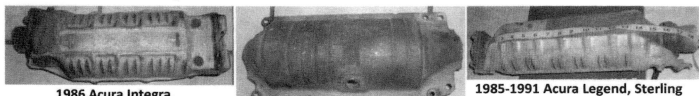

1986 Acura Integra.
1980, 1991, 1993 Honda Accord.
1980, 1983 Honda Civic.
1985 Honda CRX.
1990 Honda Prelude.
1987-1990 Sterling 825.

Price: $80

1988-2002 Honda Accord.
1988 Honda CRX.

Price: $270

1985-1991 Acura Legend, Sterling 827.

Price: $170

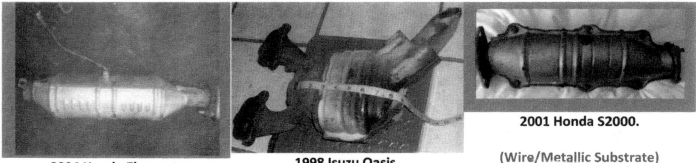

2004 Honda Element.
(4 fin X 4 fin)
Price: $265

1998 Isuzu Oasis.

Price: $60

2001 Honda S2000.

(Wire/Metallic Substrate)

Price: $12 a Pound

2001, 2003, 2005 Honda Civics.

Price: $180

2003 Acura TSX (19 ¼ in.)
2004 & 2006 Honda Accord (10 ¼ in.)
2005 Acura RSX. (17 ¾ in.)
(2 fin X 4 fin)
Price: $140

2011 Honda Accord.

Price: $60

2006 Honda Civic Coupe.

2006 Honda Civic Coupe.

2007 Honda Fit.

Price: $100

Price: $100

Price: $85

1998 Hunyadi Elantra.

H21118:$85
H41118: $85

1992-2002 Hunyadi Accent.
AF: $25
AC: $115

2005 Hyundai Accent.
DC: $85

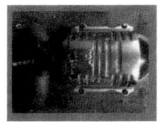

2006 Hyundai Sonata.

NFLN: $80
NFRN: $80

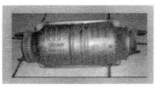

Hyundai/Kia.

2MC3U: $45
2JB3U: $60

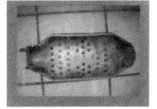

2002 Kia Sedona.

CNV01: $160

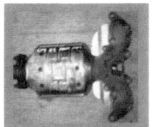

2003-2006 Hyundai Elantra.
B6E: $70

Other Numbers:
B5C: $90

2007 Hyundai Accent.

MCU: $105
TCU: $120

1998-2001 Kia Sephia.
2000-2001 Kia Spectra.
1995-1996 Kia Sportage.

K2BW $50

KIA Rio.
K2BW $115
RDH21: $110
RDH51: $40

1998 Hyundai Accent.

H1ll10: $45

1998-2002 Kia Sportage.

K08A: $70
K08B: $120

1996 Hyundai Accent, Elantra. (w/o Hangers)
H1CC18: $90

1996 Hyundai Accent. (w/hanger)
1996-2000 Hyundai Elantra. (w/hanger)
2000 Hyundai Tiburon. (w/hanger)
H2EC18: $90
H2UU15: $160

2002 & 2004 Hyundai elantra.
2007 Kia Spectra.

BSC8: $225
BSC9: $210

2001-2002 Hyundai Elantra.
U2JJ15: $100
U2CA15: $60

2003 Hyundai Tiburon.
U2JJ18: $105

2003-2005 Hyundai Elantra.
U2FE15: $60

2006 Hyundai Sonata.
25560: $55

2001-2004 Hyundai Sante FE.
SSH31: $140

Other Hyundai Numbers:
U2BSCO: $70
U2JX15: $60
U8WW18: $90
BDH21: $75

2001-2003 Hyundai Elantra.
2001-2002 Hyundai Tiburon.
B2C: $110
B2E: $85

1999-2000 Hyundai Elantra.
W4QR10: $125

2003-2004 KIA Rio.
RHC: $115
RHF: $135

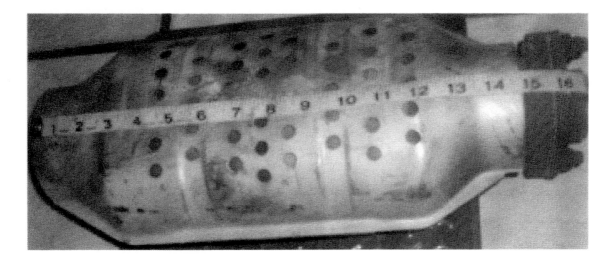

1992 Hyundai Sonata.
BJH41: $90
BJH42: $70

2000-2001 & 2005 Hyundai Sonata.
2001-2004 Kim Optima.
TSH31: $120

2002-2003 Hyundai XG350.
2001 KIA XG300
XGFL4: $80

Other Numbers:
JSH62: $85
TSH41: $195
FSH42: $115

Hyundai Numbers

H21118:$85	K2BW $115	25560: $45	TSH31: $120
H41118: $85	RDH21: $110	SSH31: $130	XGFL4: $80
AF: $25	RDH51: $40	U2BSCO: $60	JSH62: $85
AC: $115	H1ll10: $45	U2JX15: $50	TSH41: $195
DC: $85	K08A:$70	U8WW18: $85	FSH42: $115
NFLN: $80	K08B: $120	BDH21: $65	
NFRN: $80	H1CC18: $90	B2C: $110	
2MC3U: $45	H2EC18: $90	B2E: $85	
2JB3U: $60	H2UU15: $160	W4QR10: $125	
CNV01: $160	BSC8: $225	RHC: $115	
B6E: $70	BSC9: $210	RHF:$135	
B5C: $90	U2JJ15: $90	MCU: $105	
MCU: $100	U2CA15: $40	TCU: $120	
TCU: $120	U2JJ18: $95	BJH41: $90	
K2BW Pre $50	U2FE15: $60	BJH42: $70	

Other Hyundai Numbers

23260: $75	K7AE: $95	2G880: $110
2E160: $105	B6H: $60	37250: $90
2G327: $105	BDH51: $80	3C180: $75
2G330: $105	JGH62: $85	3C500: $30
2G420: $35	USM35: $125	D1AA19: $5
2G467: $115	KO8F: $90	D1AA23: $30
2G540: $105	K2AB: $35	HOCB18: $70
AG: $10	U4BSCO: $95	ISHE1: $10
AG63: $7	U4FE15: $80	USM35: $125
AK3P: $115	USBSCO: $60	
BDH21: $65	2G710: $125	

Jaguar

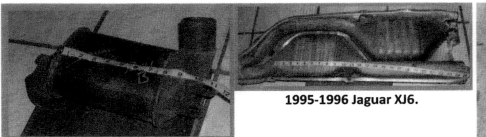

1995-1996 Jaguar XJ6.

00 & 04 3.0L & 2.5L Jaguar X-Type.

Price: $95 ea.

1983-1993 Jaguar XJ6.
1990 Jaguar XJS.
1987 Jaguar XJ12.

Price: $110

Price: $110

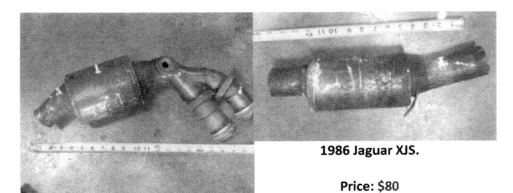

1986 Jaguar XJS.

Price: $80

1986 Jaguar XJS.

Price: $80

1994-2001 Land Rover Discovery.
1995 Land Rover Classic.
1993-1997 Land Rover Defender.
1987-2000 Land Rover Range Rover.
2000 Land Rover Vilesse.
1993-1994 Land Rover Country.

Price: $130

1994-2001 Land Rover Discovery.
1995 Land Rover Classic.
1993-1997 Land Rover Defender.
1987-2000 Land Rover Range Rover.
2000 Land Rover Vilesse.
1993-1994 Land Rover Country.

Price: $140

1994-2001 Land Rover Discovery.
1995 Land Rover Classic.
1993-1997 Land Rover Defender.
1987-2000 Land Rover Range Rover.
2000 Land Rover Vilesse.
1993-1994 Land Rover Country.

Price: $140

Mazda

**1994 Ford Probe
1992-2002 Mazda 626, MX6 &
Millenia.**

Price: $130

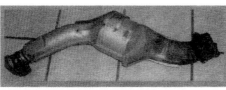

**1986-1994 Mazda RX7 Medium Foil-
Stainless Wrap.**
(weight trimmed 9 Lbs.)
Price: $12 a Pound

**1979-1983 Mazda RX7 Import Bead-
Pellet Pancake.**

Price: $55

(Must be Shaken)
(All bead-Pellet pancakes must be
shaken to verify contents. Heavy
bead with little sound denotes a full
bead.)

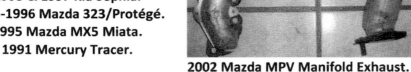

**1995 & 1997 Kia Sephia.
1995-1996 Mazda 323/Protégé.
1995 Mazda MX5 Miata.
1991 Mercury Tracer.**

(4 Holes on Side)

Price: $130

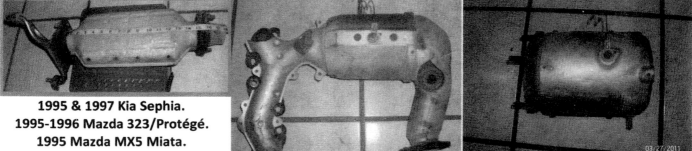

2002 Mazda MPV Manifold Exhaust.

Price: $45

**1998-2003 Mazda 323/Protégé.
2000-2002 Mazda 626.**

Price: $80

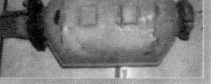

2004-up Mazda RX8.

Price: $230

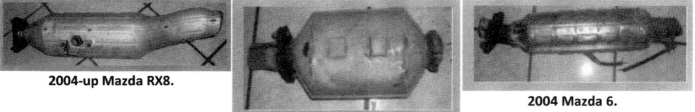

1992-1995 Mazda 929.

Price: $90

2004 Mazda 6.

Price: $185

**1998-2001 Mazda 323/Protégé.
2001-2002 Mazda Protégé.**

Price: $120

1997-2003 Mazda 323/Protégé.

Price: $60

1986-1994 Mazda RX7.

Price: $220

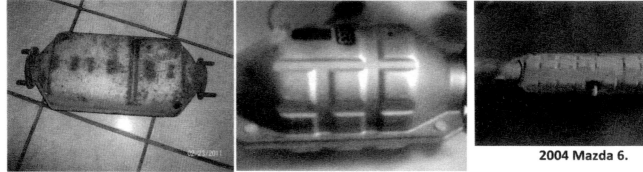

1984-1992 Mazda RX7.

Price: $230

2010 Mazda CX-10.

Price $95

2004 Mazda 6.

Price: $185

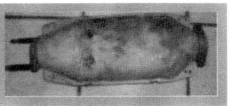

1994-2000 Mitsubishi Galant.
2000 Mitsubishi Eclipse.

Price: $50

1995 Mitsubishi Montero.

Price: $75

1989-1992 Dodge Colt.
1988 Dodge Conquest.
1989 Dodge Raider.
1989-1990 Dodge Vista.
1995 Chrysler Sebring.
1995-1996 Chrysler Avenger.
1990 & 1995 Eagle Summit.
1992 Hyundai Scoupe, Mitsubishi Expo.
1993 Mitsubishi Diamante.
1989-1992 Mitsubishi Eclipse.
1983-1993 Mitsubishi Galant, Pick-up.
1985-1994 & 1999 Mitsubishi Mirage.
1987-1990 Mitsubishi Montero,
Van/Wagon.
1989 & 2002 Plymouth Laser.

Price: $80

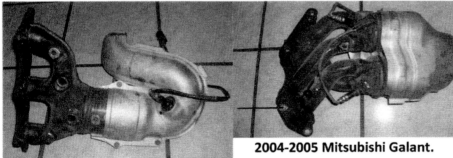

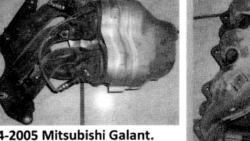

2006 Mitsubishi Eclipse.
2004 Mitsubishi Galant.
2004-2004 Mitsubishi Endeavor.

Price: $40

2004-2005 Mitsubishi Galant.
2004 & 2007 Mitsubishi Eclipse.

Price: $70

2004 Chrysler Sebring Coupe.
2001-2004 Dodge Stratus. 2001-
2003 Mitsubishi Galant.
2001-2003 Mitsubishi Eclipse.

Price: $50

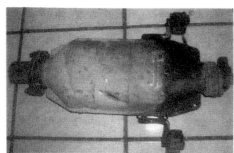

**1995 Dodge Avenger.
1995-1997 Eagle Talon.
1996-1999 Mitsubishi Eclipse.
1994-1998 Mitsubishi Galant.**

Price: $90

**1988 Dodge Conquest.
1990 Dodge Vista, Eagle Summit,
Hyundai Sonata.
1993 Hyundai Elantra, Mitsubishi
Diamante.
1992 Mitsubishi Expo.
1989-1992 Mitsubishi Eclipse.
1983-1993 Mitsubishi Galant,
Pick-up,
1985-1994 Mitsubishi Mirage.
1987-1990 Mitsubishi Montero,
Van/Wagon.**

Price: $65

2001 Mitsubishi Montero.

Price: $50

**1984-1990 Chrysler Conquest.
1984-1989 Dodge Conquest.
1990 Dodge Vista, Eagle Summit.
1981-1983 Dodge Colt.
1983-1988 Mitsubishi Cordia, Tredia.
1983-1993 Mitsubishi Pick-Up, Galant.
1987-1990 Mitsubishi Montero.
1985-1994 Mitsubishi Mirage.
1992 Mitsubishi Expo.
1989-1992 Mitsubishi Eclipse.
1993 Mitsubishi Diamante.**

Price: $100

**1997 Mitsubishi Diamante.
1995 & 2000 Mitsubishi Montero.**

Price: $180

**1994-2000 Chrysler Sebring. Mitsubishi
Eclipse, Galant.**

Price: $65

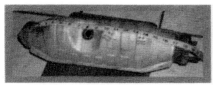

2007-Up Mitsubishi Evo.

Price: $250

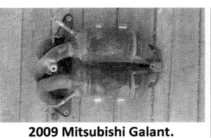

2009 Mitsubishi Galant.

Price: $70

2001 Mitsubishi Montero.

Price: $50

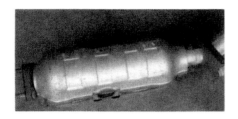

2008 Mitsubishi Lancer.

(weight trimmed 10 Lbs.)

Price: $12 a pound

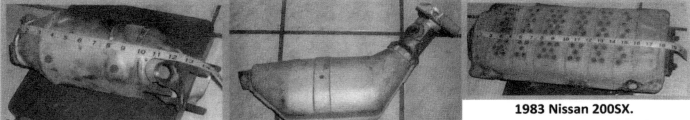

1999-2003 Nissan Frontier.
2000-2002 Nissan Xterra.

Price: $50

1999-2004 Nissan Frontier.
2003 Nissan Xterra.

Price: $60

1983 Nissan 200SX.
1987-1994 Nissan Pathfinder.
1987 Nissan Sentra.
1987-1992 Nissan Van.
1987 Nissan Pick-up.
1979 Nissan 1200.
1997 Nissan 240SX.
1993 Nissan Maxima

Price: $175

2004 Infiniti QX56.
2004-2005 Nissan Armada.
2005 Ininiti QX60, QX61, Nissan Frontier.
2006 Nissan Titan.

Price: $30

2003-2004 Infiniti FX35.
2003 & 2005-2007 Infiniti G35.
2004-2006 Nissan 350Z.

Price: $85

2000-2002 Nissan Sentra.

Price: $75

2003-2004 & 2006 Nissan Murano.
2003 & 2006 Nissan Altima.
2004 & 2006 Nissan Maxima.

Price: $40

2002 & 2004 Infiniti Q45
2004 Infiniti M45.
(Weight trimmed 6 Lbs.)
Price: $11 a Pound

1977-1978 & 1997-1998 Nissan 200SX.
1994 & 1996-1999 & 2001 Nissan Sentra.
2000 & 2002 Infiniti G20.

Price: $80

2011-Up Nissan GTR.

Price: $80

1997 Infiniti Q45.

Price: $100

2004-2006 Nissan Altima.
2005-2006 Nissan Sentra.
(Long Neck)
Price: $25

2004 Infiniti QX56.
2005 Infiniti QX62, QX63.
2004 Nissan Armada.

Price: $30

1994-2002 Mercury Villager.
1994-1998 Nissan Quest.

Price: $50

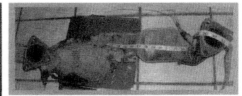

2007 Nissan Altima.

Price: $60

1996-2001 Nissan Altima.

Price: $75

2004 Infiniti F35.
2002 & 2004 Infiniti Q45.
2004-2005 & 2007 Nissan Armada.
2004- 2006 Nissan Titan.
2004 Infiniti M45, QX56,
2005 Infiniti QX56, QX58.
2004-2007 Nissan Armada, Titan.

Price: $40

1995-2000 Infiniti I 30.
1995-1998 Nissan Maxima.

Price: $25 ea.

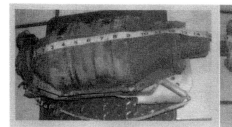

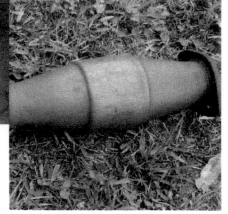

1993-1994 Infiniti G20.
1979 Nissan 1200.
1983 & 1995-1997 Nissan 200SX.
1993 & 1995-1998 Nissan Maxima.
1992 Infiniti G30.
1994 Nissan Pathfinder.
1993-1995 Nissan Pulsar.
1987 & 1991-1992 & 2001 Nissan Sentra.
1996-2000 Infiniti I30.
1997 Nissan Altima

Price: $100

1992 & 2000 Infiniti G 30.
1993-1995 & 1997-1998 Mercury Villager.
1978-1979 Nissan 210, 1200.
1983 Nissan 200 SX.
1997 Nissan 240 SX.
1993-1995 Nissan Altima.
1998-2000 Nissan. Frontier.
1991 & 1993 Nissan Maxima.
1995 Nissan Pathfinder.
1994-2000 Nissan Quest.
1987 Nissan Sentra.
1990 Nissan Sentra.
1994-1997 Nissan Pick-up.

Price: $140

2006 Nissan Maxima.
2004 Nissan Altima/Maxima.

Price: $35

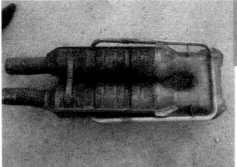

1988 & 1990 Porsche 924.

2000 & 2004 Audi A4.
2000-2004 VW Passat.

(weight trimmed 6 Lbs.)
Price: $12 a Pound

1985-1998 Porsche 928.

Price: $140 (2 Chambers)
$170 (3 Chambers)

Price: $220

1981-1984 Porche 928.

Price: $260

Saab

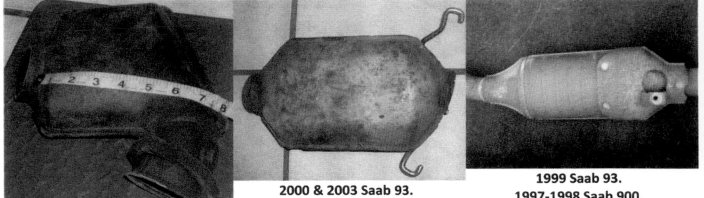

2000 Saab 95.

Price: $60

2000 & 2003 Saab 93.

Price: $75

1999 Saab 93.
1997-1998 Saab 900.
1992-1993 & 1996 Saab 9000.

(Weight trimmed 9 Lbs.)
Price: $12 a Pound

1986 Saab.

Price: $100

2007 SAAB 93.

Price $100

Subaru

2000-2004 Subaru Forester.
2000 Subaru Impreza.
2000-2002 Subaru Legacy/Outback.

2002-2003 Subaru Impreza.

Price: $95

1994 Geo Tracker.
1999 Subaru Forester.
1993-1995 Subaru Impreza.
1995-1998 & 2000 Legacy/Outback.

Price: $50

(Late Model)

Price: $80

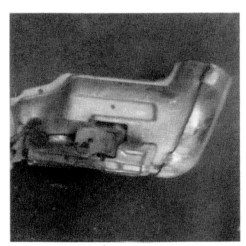

2007 Subaru Impreza.
2006 Subaru Forester.

Price: $110

Toyota

1992-1997 Lexus LS 400.
1992-1996 Lexus SC400.

Price: $75

1998-2003 Lexus GS300.
2002 Lexus IS300
1998 Lexus SC300.

Price: $70 ea.

1996-1997 Toyota Rav4.

Price: $25

1992-1993 & 1995 Lexus LS400 Z Shape.

Price: $40

1985 Chevrolet Nova.
1991 Lexus ES 250.
1987-1993 Toyota 4-Runner.
1989 Toyota Camry.
1981-1983 Toyota Celica.
1982-1989 Toyota Corolla.
1981-1983 Toyota Corona.
1988-1992 Toyota Pick-Up.
1981-1984 Toyota Starlet.
1987-1993 Toyota Tercel/Cordia.

(No Airpipe)
Price: $120

2002-2005 Toyota Camry.

(OH010)

Price: $90

1

996-1998 Toyota Supra.
1995 Lexus SE300.
1995-1997 Lexus GS300.
1997 Lexus SC300.
(Weight trimmed 6 Lbs.)
Price: $11 a Pound

2005 Toyota Avalon.

Price: $90 (R0P040)
$70 (L0P040)

2005 Toyota Sequoia.

MA1: $120

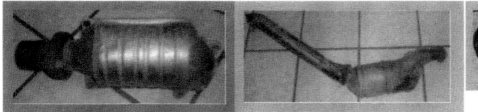

**1999-2002 Toyota
4-Runner
2000-2002 Toyota Tundra.
2000-2004 Toyota Tacoma.**

(weight trimmed 5 Lbs.)

Price: $12 a Pound

**1993-1997 Lexus GS 300.
1992-1997 Lexus SC 300.
1995 SE 300, Mercedes-Benz SC 300.
1994 & 1997-1998 Toyota Supra.**

(Weight trimmed 5 Lbs.)

Price: $11 a Pound

**2002 Toyota Camry.
"GL9" Price: $40
2002 & 2004 Pontiac Vibe.
"GL9" Price: $40
2002-2004 & 2006 Toyota Corolla.
"GL9" Price: $40
2003 Toyota Matrix.
"GL9" Price: $40
2005 Toyota Avalon.
"GL9" Price: $40**

**2004-2005 Toyota Rav4.
"GB3"$40
2005 Toyota Avalon.
"GA5" $40
2002 Toyota Camry.
"GF5" $40
2007 Toyota Prius.
"GD3" $125**

**2000 Toyota 4-Runner.
2000-2004 Toyota Tacoma.**

"GA9" Price: $90

**2004 Toyota 4-Runner.
2006 Toyota Tacoma.
"17150-31010" $70
"17140-31010" $70
"17150-OPO101" $90
"17140-OPO101" $70**

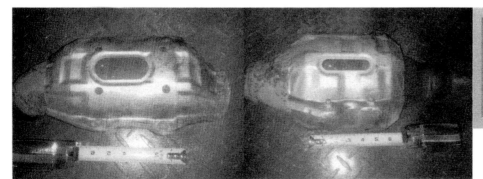

**2006 Toyota Tundra.
"T33" Price: $70
2006-2007 Toyota Tacoma.
"T32" Price: $70
2004-2006 Scion XB & 2000-2002
Toyota Echo.
"T24" Price: $90
"T15" Price: $120
2002 Toyota Camry.
"T62" Price: $90**

**1999-2004 Toyota Celica.
"X02" Price: $130
"X03" Price: $120
2003 Pontiac Vibe.
"X09" Price: $120
2006 Toyota Sienna.
"X16" Price: $70
2000 Toyota MR2.
"X05" Price: $70**

**1999-2004 Toyota Celica.
"X02" Price: $130
"X03" Price: $120
2003 Pontiac Vibe.
"X09" Price: $120
2006 Toyota Sienna.
"X16" Price: $70
2002 Toyota Camry.
"X24" Price: $70**

2007 Toyota Prius.

"EA6" $130

1996 Toyota Paseo.
"T01" Price: $60

1995 & 1997-1999 Tercel/Cordia.
"T01" Price: $60

2002 & 2004 Pontiac Vibe.
"GB8" Price: $140
2002-2004 & 2006 Toyota Corolla.
"GB8" Price: $140
2003 Toyota Matrix.
"GB8" Price: $140
2006 Toyota Corolla.
"GE1" Price: $70
2005 Toyota Matrix.
"GE1" Price: $70

1998 Lexus SC 400.

"GA4" = Price: $125

1987-1992 Toyota Camry, Celica.
1991-1992 Toyota MR2. 1986-1990
Toyota Supra.

Price: $70

2002-2004 Toyota Camry XLE, SE, LE.

"28180" = $300

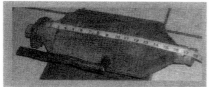

1987-1993 Toyota 4-Runner.
1989 Toyota Camry.
1981-1983 Toyota Celica.
1982-1989 Toyota Corolla.
1981-1983 Toyota Corona.
1988-1992 Toyota Pick-Up.
1987-1993 Toyota Tercel. 1981-1984
Toyota Starlet.
1985 Chevrolet Nova.

Price: $100

2001-2004 Toyota Sequoia

HA1- Price: $140

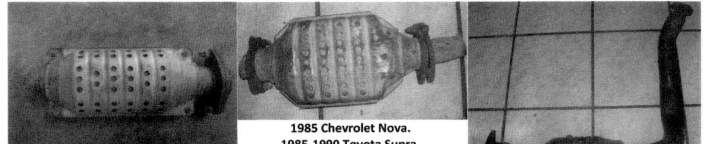

2000-2002 Toyota 4- Runner.
"U26" Price: $70
1998-2000 Toyota Rav4.
"U04" Price: $70
2000-2004 Toyota Tacoma.
"U64" Price: $60
2007 Toyota Tacoma.
"U57" Price: $90
1997-1998 Lexus ES 300.
"U99" Price: $90
1997-2001 Toyota Camry.
"U99" Price: $90
1997-1999 Toyota Avalon.
"U99" Price: $90
1999-2000 Toyota Sienna.
"U99" Price: $90
1998-2000 Toyota Sienna.
"U92" Price: $60
2001-2003 Toyota Sienna.
"U67" Price: $60
1996-2001 Toyota Camry.
"U98" Price: $60
2005 Toyota Camry.
"U50" Price: $180
2000-2002 Toyota Avalon.
"U65" Price: $70
"U68" Price: $70
1998-2002 Toyota Corolla & 1998 & 2001
Geo Prizm.
"25320303" Price: $115
"25178774" Price: $60

1985 Chevrolet Nova.
1985-1990 Toyota Supra.
1981-1984 Toyota Starlet.
1989-1993 Geo Prizm.
1985-1989 Toyota MR2.
1983-1994 Toyota Corolla.
1992 Toyota Paseo.
1983-1994 Toyota Tercel
1984-1989 Toyota 4-Runner.
1983-1990 Toyota Camry.
1983-1990 Toyota Pick-up.
1995-2000 Toyota Tacoma.
1986-1989 Toyota Van.
1985-1992 Toyota Cressida.
1983-1992 Toyota Celica.

Price: $80

2004 Toyota 4-Runner.
"T27" Price: $60
2004-2006 Scion XB.
"T24" Price: $90
"T15" Price: $125
2000-2002 Toyota Echo.
"T24" Price: $90
"T15" Price: $125
2006-2007 Tacoma.
"T32" Price: $60
"T33" Price: $60
2006 Tundra.
"T32" Price: $60

1987-1993 Toyota 4-Runner.
1980-1982 Toyota Corolla.
1983-1984 Toyota Cressida.
1989-1994 Toyota Pick-up.
S99: $125
S93: $130
(9-Line)

1987-1993 Toyota 4-Runner.
1980-1982 Toyota Corolla.
1983-1984 Toyota Cressida.
1989-1994 Toyota Pick-up.
1996-1998 Toyota T-100.
S96: $125
S94: $130
(8-Line)

1996-1998 & 2000 Toyota 4-Runner.
1980-1083 Toyota Corolla.
1983-1984 Toyota Cressida.
2000 Toyota Tundra.
S91: $125

1996-2000 Toyota 4-Runner.
S92: $170

Other Numbers:
H01: $140
H02: $150
H04: $180
H05: $130
S95: $110

Code		Code		Code		Code	
0H010	Richman	G68	Med Import	MA3	Med Import	U38	LO
0H040	Richman	G69	Med Import	NA2	Imp Pre	U43	Camry
0H050	Richman	GA1	Richman	NA3	Richman	U48	Med Import
0H090	Camry	GA3	Camry	NA5	Imp Pre	U50	XL Import
0L030	1/2 Imp Pre	GA4	Med Import	NB8	Imp Pre	U52	Camry
0V010	1/2 Richman	GA5	1/2 Camry	NC9	1/2 Fat	U55	1/2 Fat
0	Sm Import	GA6	Camry	PA1	1/2 Fat	U56	1/2 Fat
0	Sm Import	GA9	Camry	R0P040	Richman	U57	Richman
0	Medium Imp	GB2	IPRE	R0P090	Camry	U60	1/2 Fat
0	XL Import	GB3	1/2 Camry	R0P150	Camry	U61	1/2 Fat
17140-31010	Camry	GB5	1/2 Camry	R20030	Richman	U63	Med Import
17140-31011	Camry	GB7	1/2 Camry	R20040	Richman	U64	Lo Grade
17140-31070	Camry	GB8	Med Import	R20050	Richman	U65	Camry
17150-0P010	Richman	GC1	Richman	R31050	Richman	U67	1/2 Fat
17150-0P020	Camry	GC2	Import Pre	R31160	Richman	U68	Camry
17150-0P070	Camry	GC3	Import Pre	R50060	Richman	U69	Camry
17150-0P140	Richman	GC5	Fat	RA5	Richman	U77	Richman
17150-31010	Camry	GC8	1/2 Sm Imp	RA6	Lo Grade	U80	Camry
17150-31011	Camry	GD2	1/2 Sm Imp	S91	Med Import	U85	Camry
17150-31210	Camry	GD3	Lg Import	S92	Med Import	U87	Sm Import
17150-31240	Camry	GD5	1/2 Camry	S93	Med Import	U88	Med Import
17150-D	1/2 Imp Pre	GD6	Med Import	S94	Med Import	U89	Camry
28080	Medium Imp	GD8	Import Pre	S96	Med Import	U90	1/2 Richman
28090	Medium Imp	GD9	1/2 IPRE	S99	Med Import	U91	Camry
28100	Richman	GE1	Lo Grade	T01	Lo Grade	U92	1/2 Fat
28180	EXOT	GE2	Richman	T12	Lo Grade	U93	Camry
28220	1/2 Sm Imp	GE3	1/2 Sm Imp	T15	Med Import	U94	Med Import
28260	Medium Imp	GE5	1/2 Camry	T24	Sm Import	U95	1/2 Med Imp
28310	Lg Import	GE6	1/2 Camry	T26	1/2 Camry	U96	1/2 Med Imp
28330	Richman	GF5	1/2 Camry	T27	1/2 Camry	U97	1/2 Fat
28350	Richman	GF7	Import Pre	T32	1/2 Richman	U98	Lo Grade
25129240	Camry	GF8	Import Pre	T33	1/2 Richman	U99	Richman
25129240	Camry	GF9	Import Pre	T34	Richman	UA1	Richman
25162672	Camry	GG7	Import Pre	T35	Camry	UA2	Richman
25162672	Camry	GG8	1/2 Richman	T37	1/2 Camry	UA3	Richman
25174321	Camry	GH2	1/2 Camry	T38	1/2 Richman	UA4	Med Import
25178774	1/2 Richman	GH5	Camry	T48	1/2 Camry	UA6	Richman
25320303	Medium Imp	GH7	Fat	T50	1/2 Lg Import	UA7	Richman
31050	Richman	GJ4	Import Pre	T51	1/2 Lg Import	UB4	Camry
31160	Richman	GJ5	Old Pre	T55	Lo Grade	UB5	1/2 Sm Imp
51010	Lo Grade	GJ7	Import Pre	T61	Med Import	UB6	Richman
A01	Camry	GK5	1/2 Camry	T62	Sm Import	UC3	Camry
AB7	1/2 Imp Pre	GK6	Med Import	T63	Lo Grade	UC6	1/2 Fat
AG1	1/2 Imp Pre	GK7	Lo Grade	T64	1/2 Richman	X01	1/2 Fat
B01	Camry	GL4	1/2 Camry	T65	Med Import	X02	Lg Import
B03	Camry	GL6	Import Pre	T66	1/2 Richman	X03	Med Import
B04	Camry	GL8	Med Import	T67	Sm Import	X04	Camry
B09	Camry	GL9	1/2 Camry	T69	Camry	X05	Camry
B12	Camry	GM3	1/2 Med Imp	T90	Lo Grade	X09	Lg Import
B87	Camry	GM6	1/2 Camry	TA4	Camry	X12	Camry
B97	Camry	GM7	Import Pre	TA8	Camry	X16	Camry
B98	Camry	GN1	1/2 Camry	TA9	Camry	X18	Camry
C08	Camry	GP1	Richman	TB1	Lo Grade	X23	Camry
C09	Camry	GP6	Import Pre	TB3	1/2 Imp Pre	X24	Lo Grade
C11	Camry	GT4	Lo Grade	TC7	1/2 Camry	X25	1/2 Sm Imp
CA4	Import Pre	GT9	1/2 IPRE	TF4	Camry	X32	1/2 Fat
CA6	1/2 Sm Imp	GW4	Import Pre	U01	1/2 Sm Imp	X34	Camry
DA1	1/2 Sm Imp	GW8	Import Pre	U02	Camry	X35	Camry
DA2	1/2 Sm Imp	GX1	1/2 IPRE	U03	1/2 Sm Imp	X48	1/2 Richman
E03	Sm Import	H01	Lg Import	U04	Camry	X49	Lo Grade
E05	Sm Import	H02	Lg Import	U08	1/2 Fat	X50	Lo Grade
E12	Fat	HA1	Lg Import	U09	Lo Grade	X62	Lo Grade
E15	Sm Import	HA3	Lg Import	U10	Richman		
E15	Fat	JA4	Lg Import	U11	1/2 Fat		
E52	Sm Import	JM1DQ	1/2 Fat	U13	1/2 Fat		
E96	Fat	JM4XF	Lg Import	U14	Camry		
E97	Fat	KSN29	Small Import	U15	Camry		
E99	Sm Import	L0P040	Camry	U20	1/2 Fat		
EA1	Richman	L0P049	Lo Grade	U21	1/2 Fat		
EA6	Fat	L0P090	Camry	U22	Med Import		
EU37B3	Import Pre	L20190	Camry	U25	Lg Import		
F02	Fat	L20210	Camry	U26	Camry		
F03	Fat	L20220	Camry	U27	Richman		
F04	Sm Import	L31050	Richman	U28	Richman		
F12	Sm Import	L31150	Richman	U31	Richman		
F16	Sm Import	L38020	Lg Import	U32	Richman		
F98	Sm Import	LA2	Med Import	U34	1/2 Richman		
F99	Sm Import	LA4	Med Import	U35	Richman		
FL45	Import Pre	MA1	Med Import	U37	Camry		

1999 VW Golf
1999-2001 VW Jetta.
2000-2002 VW GTI.

(Weight trimmed 8 Lbs.)
Price: $12 a Pound

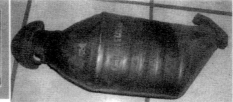

1998-1999 Volkswagen Passat.
1997-1999 Audi A4.

Price: $125

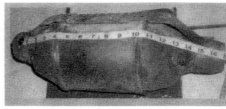

1998-2001 & 2004 VW Beetle.
1999-2001 VW Golf, Jetta.

Price: $165

*Fat Can

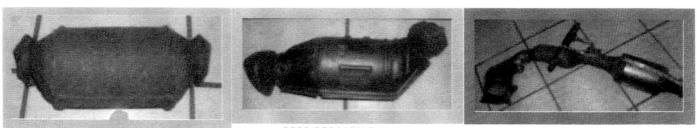

1979 VW Beetle.
1981 VW Dasher.
1984 VW Jetta.
1990 VW Fox.
1990 VW Cabriolet.
1992 VW Pick-Up.
1987-1988 Audi 80.
1987 Audi 90.
1989-1991 Audi 100.
1989 Audi 200.
1982-1987 Audi 4000.
1977-1990 Audi 5000.

Price: $110

2000-2004 VW Passat.
2000 & 2004 Audi A4.

(weight trimmed 7 Lbs.)

Price: $12 a Pound

2006 VW Jetta/Passat.

Price: Pre Import = $40
Regular Import = $80

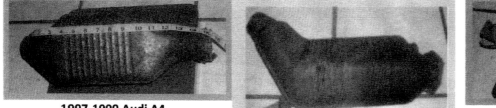

1997-1999 Audi A4.
2001 Audi A6.
2003-2004 VW Passat.

Price: $85

1992-1994 Audi 100.
1993 Audi 90.
1996 Audi A6.

Price: $140

1977-1988 Audi 80.
1987 Audi 90. 1989-1991 Audi 100.
1989 Audi 200.
1982-1987 Audi 4000 1977-1990 Audi 5000.
1979 VW Beetle. 1981 VW Dasher.
1984 Vanagon.
1984 VW Jetta. 1990 VW Cabriolet.
1990 VW Fox. 1992 VW Pick-up.
1990 Audi Coupe.

Price: $70

Volkswagen

2012 Volkswagen Jetta.
2012-2013 Volkswagen Passat.

Price: $120

Volvo

1992 Volvo 240.
1982-1992 Volvo 740.
1985-1991 Volvo 760.
1989-1990 Volvo 780.
1991 Volvo 940.

Price: $120

1996 Volvo 850.
1999 Volvo S70, V70.
(2 chambers & wire)

Price: $200

1995 Volvo 850.

(2 chambers only)

Price: $140

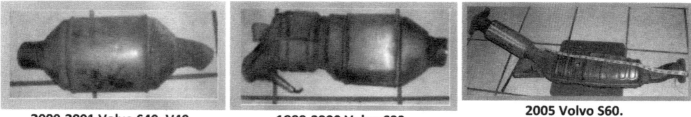

2000-2001 Volvo S40, V40.

Price: $90

1999-2000 Volvo S80.

Price: $90

2005 Volvo S60.

(2 chambers)

Price: $130

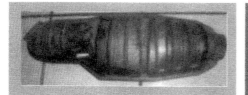

2000 Volvo V60.
2001 Volvo V70 XC.
2002 Volvo C70.

(1 chamber & wire)

Price: $140

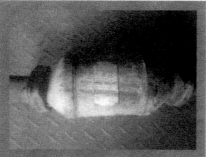

1976-1984 Non-Turbo Volvo 240.
1976-1983 Volvo 260.
1982-1985 Renault Fuego.
1980-1983 Renault R-18i.

Price: $90

1999-2000 Volvo S80.

Price: $100

Volvo

2001 Volvo S60.

Price: $11 lbs.

(Weight trimmed 7 Lbs.)

**1993 Volvo 940 & 1992, 1996-1997
Volvo 960 & 1998 Volvo V90.**

Price: $375

Colophon

© **2019** Cameron Rowland and Koenig Books, London

First published by Koenig Books, London

Koenig Books Ltd
At the Serpentine Gallery
Kensington Gardens
London W2 3XA
www.koenigbooks.co.uk

Printed in Germany

Distribution

Germany, Austria, Switzerland / Europe
Buchhandlung Walther König
Ehrenstr. 4,
D - 50672 Köln
Tel: +49 (0) 221 / 20 59 6 53
verlag@buchhandlung-walther-koenig.de

UK & Ireland
Cornerhouse Publications Ltd. - HOME
2 Tony Wilson Place
UK – Manchester M15 4FN
Tel: +44 (0) 161 212 3466
publications@cornerhouse.org

Outside Europe
D.A.P. / Distributed Art Publishers, Inc.
75 Broad Street, Suite 630
USA - New York, NY 10004
Tel: +1 (0) 212 627 1999
orders@dapinc.com

ISBN 978-3-96098-013-1